ALPHABETS & NUMBERS OF THE Middle Ages

ALPHABETS & NUMBERS OF THE Middle ages

By Henry Shaw

· INTRODUCTION BY ·

ROWAN WATSON

NATIONAL ART LIBRARY
VICTORIA AND ALBERT MUSEUM
LONDON

BRACKEN
BOOKS
LONDON

Originally published as
Alphabets, Numerals and Devices of the Middle Ages
by William Pickering
London
1845

This edition is published by Bracken Books,
a division of Bestseller Publications Ltd,
Princess House, 50 Eastcastle Street,
London W1N 7AP, England

ISBN 1 85170 191 5

Printed and bound by Leefung-Asco Printers
Hong Kong

THE PLATES

Pages

FROM A COPY OF ST. CUTHBERT'S GOSPEL IN THE BRITISH MUSEUM, COMMONLY CALLED THE DURHAM BOOK; written and illuminated by Eadfrith, Bishop of Lindisfarn, between the years 698 and 721. 11

All the varieties of the different Capital Letters to be found in the Volume are shown on the Plate, together with the diapering by which the larger ones are surrounded.

FROM THE BRITISH MUSEUM, ROYAL MS. I. E. VII. 13

A fine, but mutilated, copy of the Gospels, in folio. The leaves containing the figures of the Evangelists, and the titles, written in silver and gold, are on purple vellum. The rest of the volume is in uncial characters, arranged in double columns. It is most probably of the 9th century, and certainly not later than the 10th. The border is taken from the Durham Book mentioned above.

FROM THE TOMB OF GUNDREDA, SISTER OF WILLIAM THE CONQUEROR, in South-over Church, Lewes. 15

FROM THE BRITISH MUSEUM, ROYAL MS. I. C. VII. AND OTHER MSS. OF THE SAME DATE. 16, 17

A variety of Large and Small Capital Letters from various MSS. of the 12th century. The peculiar character of these Letters seem to shew a more close approximation to Greek or Roman ornament, in their elegance and simplicity, than any in use during the Middle Ages.

LETTERS IN BRONZE, FROM THE MONUMENT OF HENRY III. IN WESTMINSTER ABBEY, Date about 1272. 19

FROM THE BRASS EFFIGY OF ADAM DE WALSOKNE, in St. Margaret's Church, Lynn Regis, Norfolk. Date 1349. 21

AN ALPHABET FROM A MS. OF BOETIUS'S DE CONSOLATIONE PHILOSOPHIÆ, date 1385, in the Hunterian Museum, Glasgow, and THREE LETTERS FROM THE ROYAL MS. 6. E. IX. in the British Museum. 23

CAPITAL, AND SMALL ALPHABETS, WITH STOPS, GROTESQUES, &c. IN BRONZE, FROM THE MONUMENT OF RICHARD II. and others of about the same date, in Westminster Abbey. 24, 25

CAPITAL LETTERS FROM A VERY SPLENDID COPY ON VELLUM OF THE FIRST EDITION OF THE BIBLE, printed by Fust and Schœffer, in the British Museum. Date 1462. 27, 29, 31, 33, 35, 37

FROM LANSDOWNE MS. 451, IN THE BRITISH MUSEUM. A PONTIFICALE AD USUM ECCLESIÆ ANGLICANÆ. 38, 39

Among many other curious Forms and Ceremonies contained in this Book, the following seem deserving of notice, and may be found useful in many respects, and particularly to designers of Ecclesiastical Subjects.

The Manner and Ceremony of Ecclesiastical Tonsure.

On the Colours of Ecclesiastical Vestments, and why used on particular occasions, fol. 14.

The Consecration of Bishops according to the Roman Form, fol. 35.

The Consecration and Installation according to the English Form, fol. 41.

The Consecration of Nuns, fol. 59.

The Form of making a Recluse, fol. 62 b.

The Form of the Coronation of the Kings of England, fol. 96. b.

The Form of Dedicating and Blessing Churches, fol. 111.

Benediction of the new Episcopal Seal, fol. 172.

Benediction of Bells, fol. 176.

Benediction of a New Well, fol. 193.

Benediction of a New House, fol. 193.

Order of Espousals, with the Blessing of the Nuptial Bed, fol. 229.

From a Missal in the possession of the Rev. W. Maskell. Date, about 1470. 41

From Summa Barthomæi Pisani Ord. Prædic. de Casibus Conscientiæ. Date, about 1472. 42, 43

From a Pontificale of John II. Archbishop of Treves. Date, about 1480. 44, 45

From a MS. at Rouen, and from a Benedictionale in the possession of the Rev. W. Maskell. Date, about 1480. 47

From an Italian MS. in the Public Library at Boulogne. Date, about 1480. 49

The Sacred Monogram, from an Engraving on Wood. Date, the beginning of the 16th Century. 51

From various MSS. in the British Museum. Date, the beginning of the 16th Century. 53

From a MS. in the possession of P. A. Hanrott, Esq. and various Numerals. 55
The Series taken from the British Museum, Cotton MS. A. II. written during the latter half of the 13th Century, is supposed to be the earliest example of Arabic Numerals existing in this country. They have been found in Spanish MSS. of the 12th Century.

From a Volume entitled, Preservation of Body, Soul, Honour, and Goods. Printed at Nurenburgh. Date, 1489. And from a Gateway in Chancery Lane. Date, 1518. 57, 59

From the Stalls of St. George's Chapel, Windsor. Date, the end of the 15th Century. 61, 63

From the Golden Bible. Printed at Augsburg. Date, the end of the 15th Century. 65
These Letters have evidently been copied from an Illuminated Series, and have but a meagre effect in outline, though displaying considerable taste and elegance of arrangement, and would if skilfully and appropriately picked in with colours and gold be very effective.

From a Copy of the Romaunt of the Rose. Date, the beginning of the 16th Century. 67, 69

From Woodcuts in various printed Books. Date, the beginning of the 16th Century. 71

From the Missale Trajectense. Date, 1515. 73

From the Missale Trajectense, and Alphabets of the end of the 15th Century. 75

From an Engraving on Wood. Date, the beginning of the 16th Century. 77

From the Romance of Launcelot du Lac, from Luis de Escobar, Las Quatro Cientas del Almirante, and the Missale Eboracensis Ecclesiæ. Date, 1515, 1550, and 1516. 79

From the Hystoire de Perceval le Galloys. Date, 1530. 81

From Cranmer's Bible. Date, 1539. 83

Riband Letters, from a Volume entitled Orthographia practica, 4to. Carag. 1548. 85, 87

Sacred Monogram, from the same Book. 89

Sacred Monogram, and Badges of the Apostles, from a Volume entitled, Francisci Nigri de Arte Scribendi, Daventrie, 1495, and a Letter M from a printed Book. 91

Labels from early German Prints. 93, 95

INTRODUCTION

I N a period of abundant enthusiasm for all things medieval, Henry Shaw (1800–1873) stands out as a meticulous antiquarian scholar and draughtsman. With people like Owen Jones and Henry Noel Humphreys, he represents one of the major channels by which the Victorian period learnt what medieval art looked like. Remembered today more as an antiquarian than an architect, his works had a wide influence on the Victorian decorative and graphic arts, and provided source material drawn on by a host of designers and artists working in Gothic Revival and Renaissance styles. Drawing chiefly on illuminated manuscripts but also on early printed books and inscriptions, Shaw's *Alphabets* was one of the first – and certainly the most ambitious and impressive – works providing models for lettering and ornament.

Shaw's medieval interests went back to the 1820s when he worked with John Britton on the monumental *Cathedral Antiquities of England*. Later publications show him working with antiquarian scholars on similar ventures. Shaw's study of medieval manuscripts become apparent in his *Illuminated Ornaments of the Middle Ages* published in 1833 by William Pickering; this contained hand-coloured engravings of illuminated initials that had been published singly over the previous three years. The volume contained an historical commentary by Frederic, later Sir Frederic, Madden that enshrined the Victorian view of the development of illumination up to the Renaissance.

The plates in Shaw's *Alphabets* of 1845 were also prepared and sold singly in the two or so years before publication as a book. Huge advances had been made in the 1830s in colour printing, Owen Jones' work on the Alhambra providing a spectacular demonstration of what chromolithography could do. Even this did not satisfy Shaw's perfectionism. A much bigger work than his *Illuminated Ornaments*, many plates in the *Alphabets* of 1845 were coloured or tinted in Shaw's hand, while others were printed with coloured woodblocks or wood engravings. The result surpassed any mechanical process of the time. The printer, Charles Whittingham of the renowned Chiswick Press, feared for Shaw's health on account of the work involved. The woodblocks after Shaw's designs were cut by Mary Byfield (1795–1871), a virtuoso engraver and friend of the Whittingham and Pickering families.

The *Alphabets* of 1845 was advertised for sale by its publisher, William Pickering, in two formats, in imperial octavo at two guineas and imperial quarto at four guineas. Despite these high prices, Shaw's perfectionism prevented the publication from making profits. His later works that derived from the *Alphabets* of 1845, the *Handbook of Medieval Alphabets* published in 1853 by William Pickering and in 1856 by Henry George Bohn, were printed in sepia tint and were financially more successful. Shaw might, when asked to provide facsimiles from manuscripts in the British Museum in 1845 for the French scholar Bastard-d'Estang, give his rate as ten guineas for a small initial and fifteen for a large one, but there was no consistent patronage for work of this kind. We can regard *Alphabets* as the last work that matched Shaw's high standards before he settled for commercially available processes.

Alphabets was intended for architects and 'the various classes of decorators' engaged on restoring or emulating 'noble specimens of Ancient Art'. In the more discursive introduction to the *Handbook* of 1853, Shaw reveals his admiration for the bright colours, purple and gold of early manuscripts and his preference for the 'great strides' made in the 15th century that led to the perfection of Giulio Clovio, whom the Victorians put on a level with Raphael, in the 16th; the work of the 12th century Shaw took to be quaint and unrefined. Shaw does cover what we would call the Central Middle Ages in *Alphabets*, but shows a marked preference for designs with luxuriant decoration and striking colour. This enthusiasm for polychromy was a major aspect of Victorian – indeed European – interest in the medieval and Renaissance decorative arts.

In the wake of books like Shaw's *Alphabets* came a huge popular interest in illumination. 'Do-it-yourself' manuals abounded from the 1850s. A company like John Barnard & Son published books on alphabets for illuminators and decorative artists, and sold equipment and colours as well as outline or partially coloured designs for illuminating. Some indulged in the barbaric habit of cutting samples of illumination and lettering from original medieval manuscripts – the Victoria and Albert Museum has a collection made in the 19th century of many hundred such cuttings. When we find a writer on illumination like Albert H. Warren described as 'Instructor to the Royal Family', we can see that it had become a genteel pastime. Another writer on the subject was Laurent de Lara, 'Illuminating Artist to the Queen'; he founded the Illuminating Art Society in 1857, among whose noble patrons and members were the Viscountess Dungarvan and the Baroness de Rothschild.

Shaw had no small influence on these activities. Apart from his *Handbook* mentioned above, his *Handbook of the art of illumination as practised during the middle ages, with a description of the metals, pigments and processes employed by the artists* (1866) was perhaps the most respected work on the subject. But it was the *Alphabets* of 1845 from which the publication of 1866 derived, that we should regard as the summit of Shaw's graphic achievement.

ROWAN WATSON
Assistant Keeper
National Art Library
Victoria and Albert Museum
London

I N offering to the public a series of examples of the Alphabets, Numerals, and Devices in use during the Middle Ages, I feel that any elaborate Essay on their various styles and characters is totally unnecessary. They form but subordinate parts in a decorative Design, and being intended for the use of persons presumed to be acquainted with the chronology of mediæval art, and the general peculiarities belonging to each particular period, a careful inspection will be sufficient to shew their accordance with coæval specimens of ornament applied to other purposes.

To Architects, and the various classes of Decorators engaged, either in restoring the noble specimens of Ancient Art still remaining to us, or, in composing new ones, adapted to present requirements, in the spirit, and with the characteristics of those master-pieces of science and taste, it must be needless to point out how essential it is to the perfection of a design, that all its details should be in harmony with each other, or how necessary an intimate acquaintance with every branch of decorative art in use at the same time must be for the attainment of that harmony. I therefore trust, that the present series, selected with considerable care, engraved in various styles, and coloured where necessary, to imitate the originals, may prove extensively useful ; not only for professional purposes, but also as a text-book for the amateur and collector, by which he may be assisted in ascertaining the date of any specimen of mediæval decoration he may take an interest in, and also be better qualified to criticize and appreciate modern efforts in imitation of the various styles of Christian Art in use between the Saxon period and the Reformation.

The examples have been taken from Carvings in wood and stone, from Illuminations, from Monumental Brasses, and from early Prints, and printed Books; and shew, in their various treatment, the great skill with which the Artists applied similar forms to different materials in a manner calculated to produce the greatest effect.

<div align="right">HENRY SHAW.</div>

37 Southampton Row,
Nov. 1, 1845.

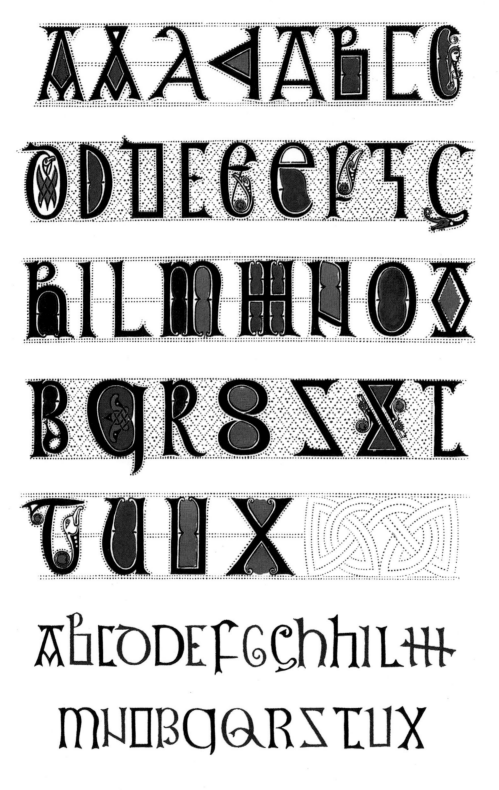

FROM A COPY OF ST. CUTHBERT'S GOSPELS IN THE BRITISH MUSEUM.

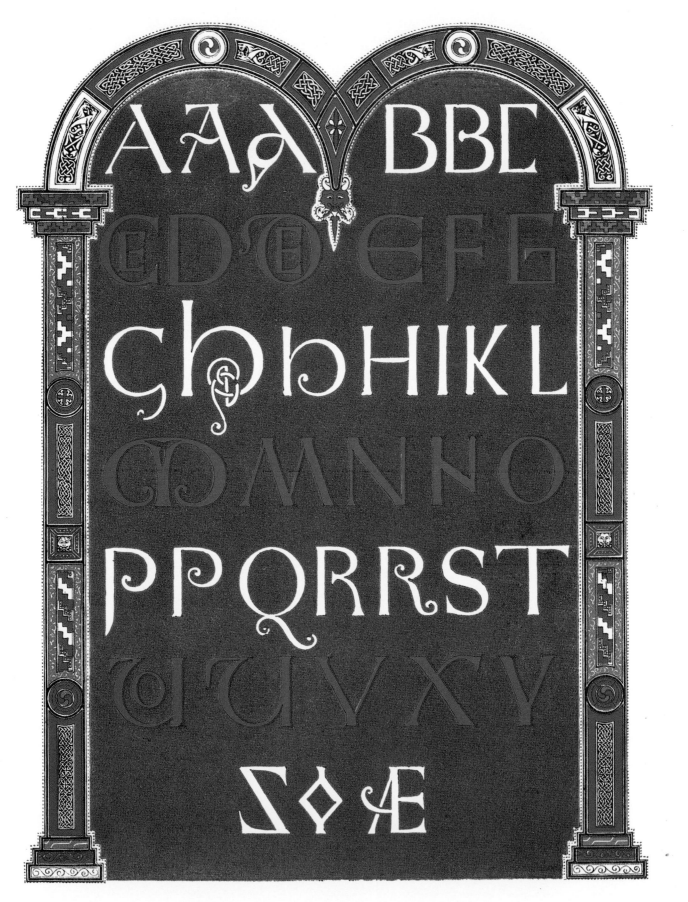

FROM THE BRITISH MUSEUM, ROYAL MS. I. E. VI.

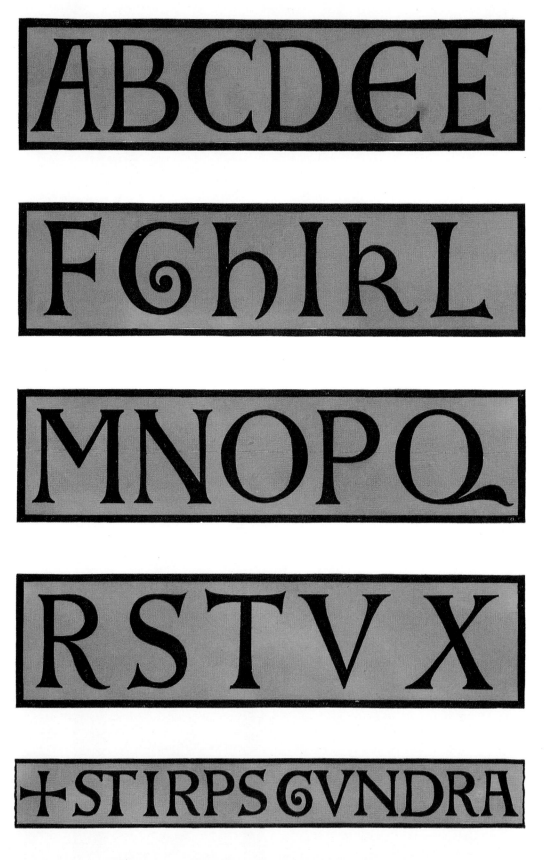

FROM THE TOMB OF GUNDREDA, SISTER OF WILLIAM THE CONQUEROR,
in Southover Church, Lewes.

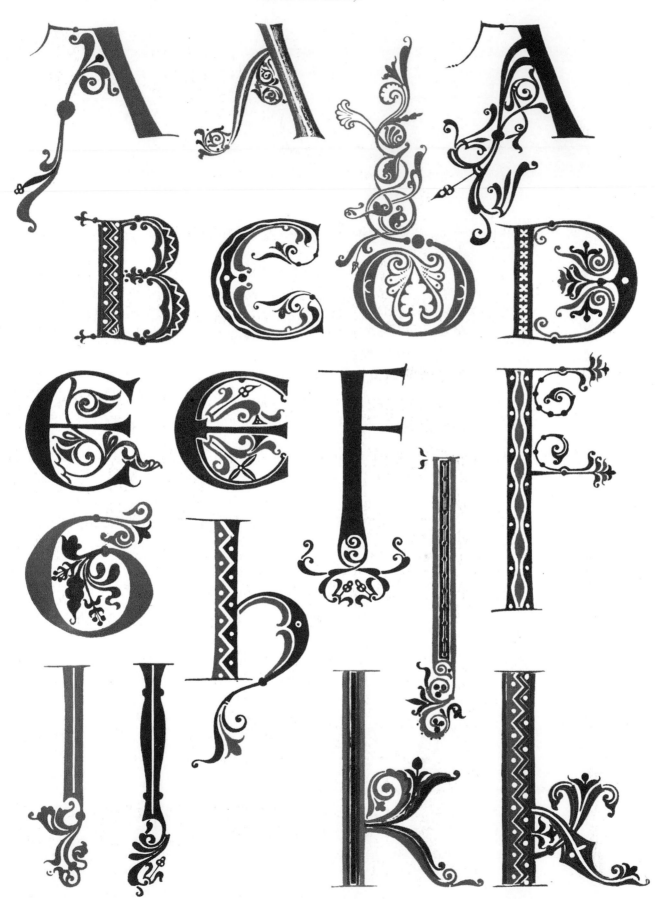

FROM THE BRITISH MUSEUM.
Royal MS. I. C. VII. and others of the same date.

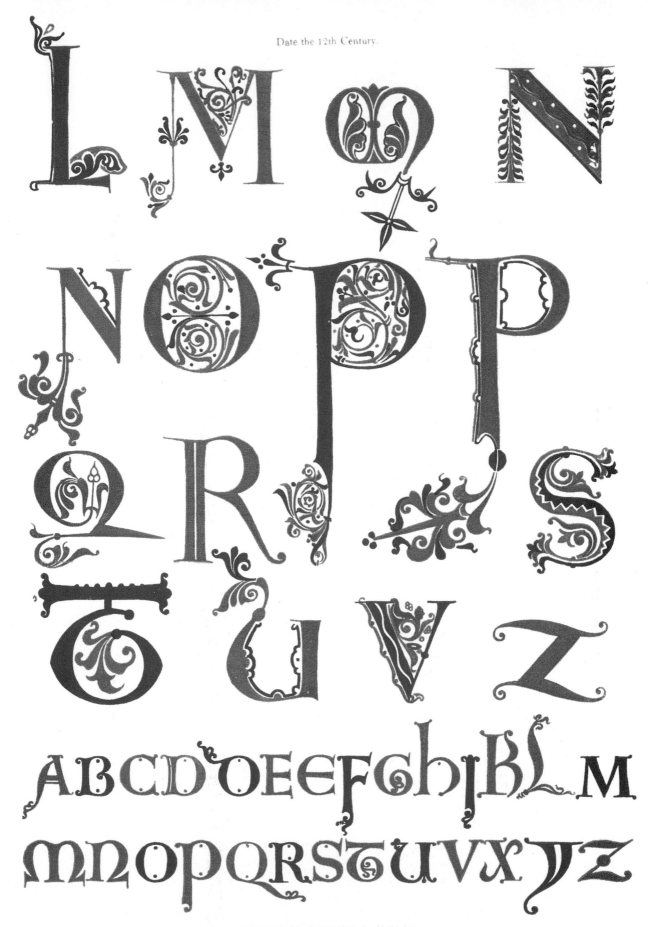

FROM THE BRITISH MUSEUM.
Royal MS. I. C. VII. and others of the same date.

17

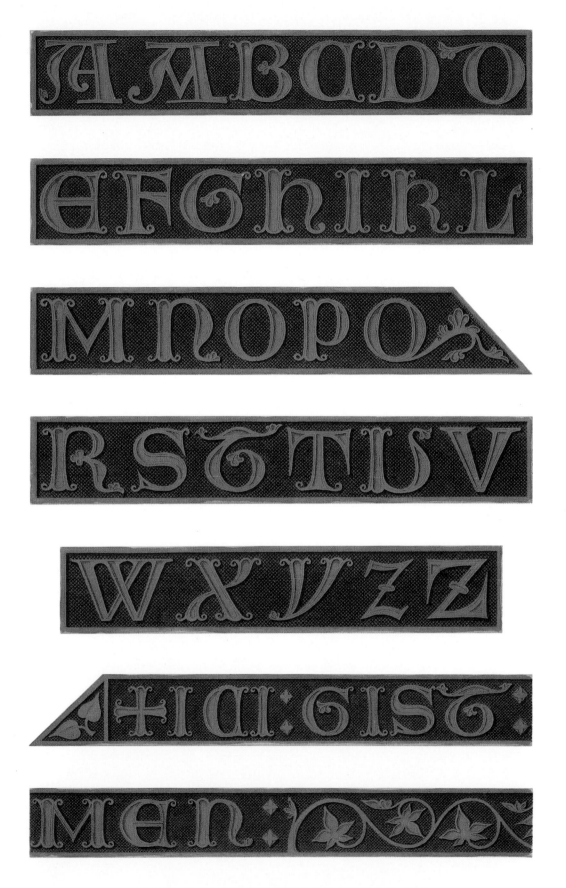

FROM THE MONUMENT OF HENRY 3RD

In Westminster Abbey.

H. Shaw.

Date. 1349.

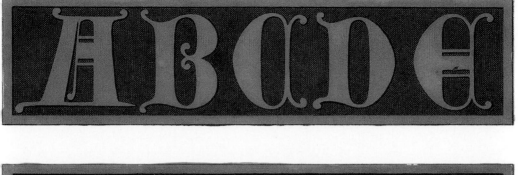

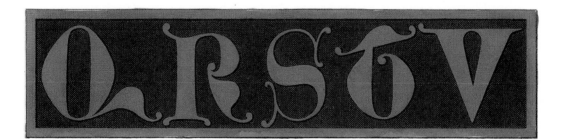

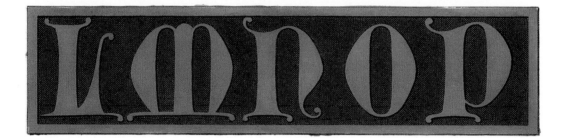

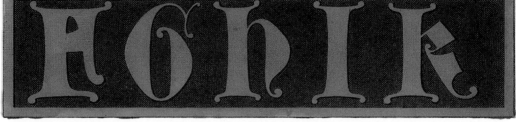

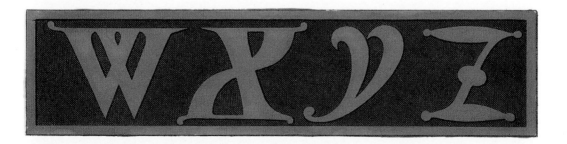

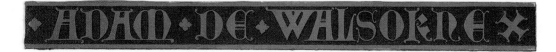

FROM ST MARGARETS CHURCH,

Lynn Regis. Norfolk.

H. Shaw.

21

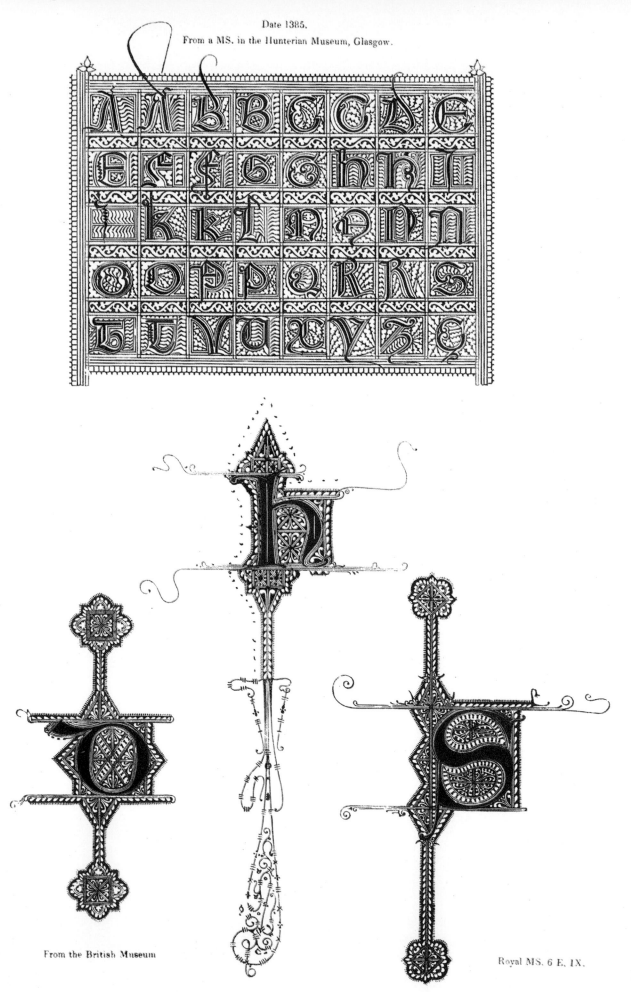

Date 1385.
From a MS. in the Hunterian Museum, Glasgow.

From the British Museum

Royal MS. 6 E. IX.

Date about 1330.

23

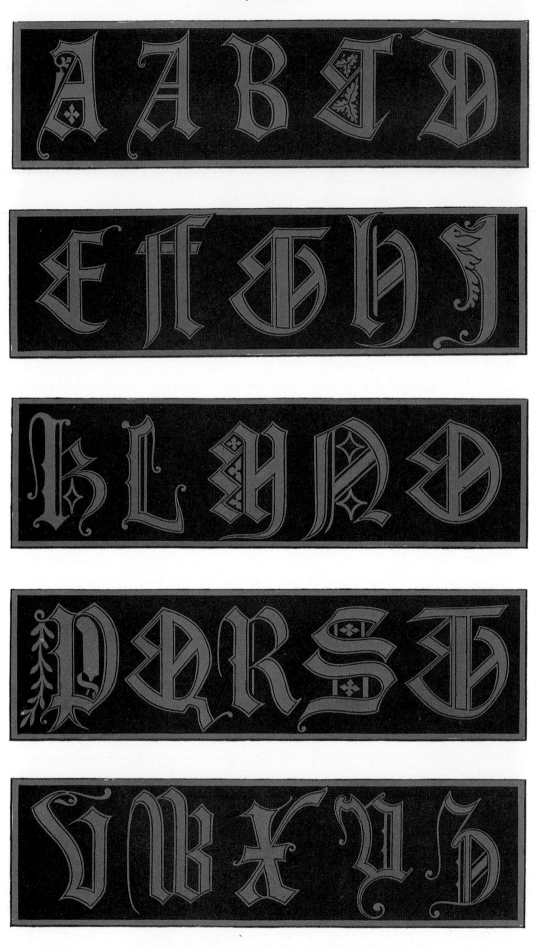

FROM THE MONUMENT OF RICHARD II. IN WESTMINSTER ABBEY,
AND OTHERS OF THE SAME DATE.

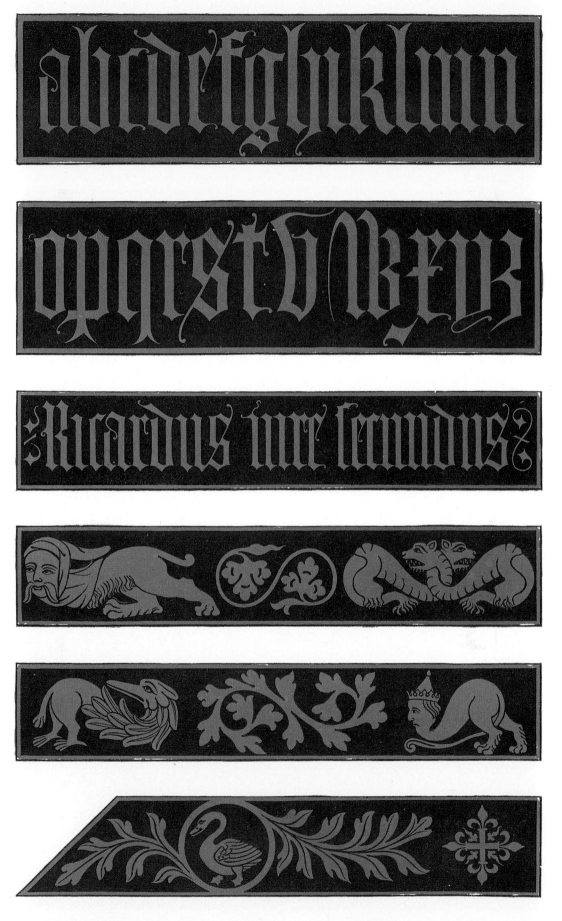

FROM THE MONUMENT OF RICHARD II. AND OTHERS ABOUT THE SAME
DATE, IN WESTMINSTER ABBEY.

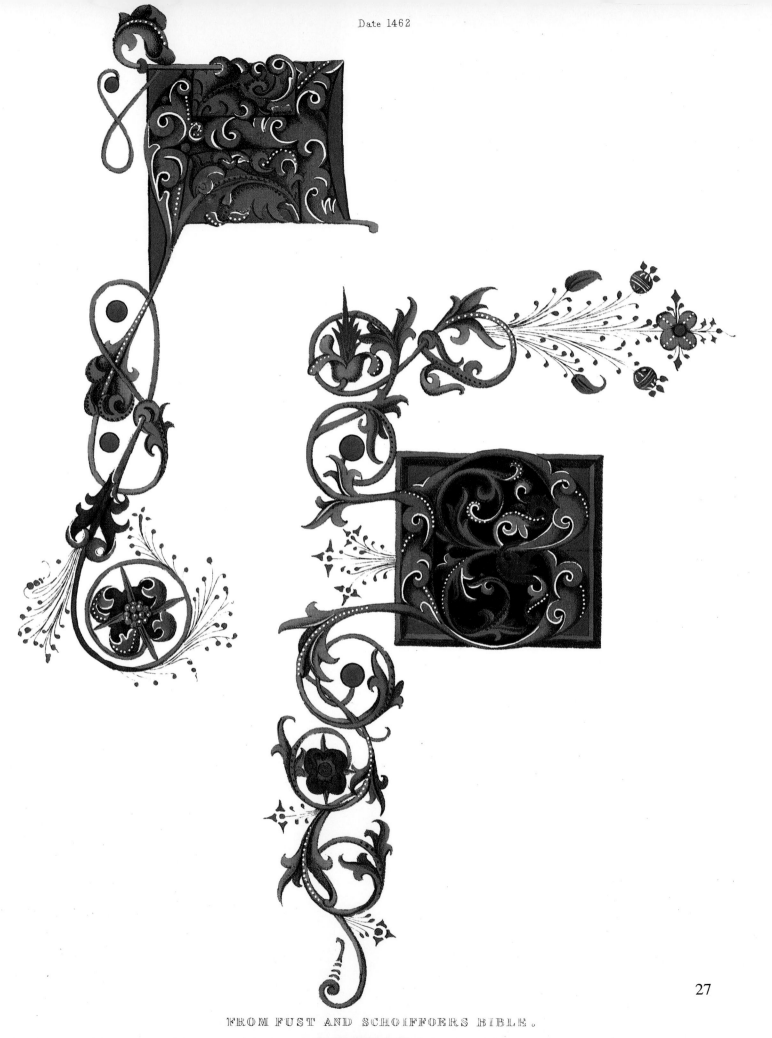

FROM FUST AND SCHOIFFOERS BIBLE.

In the British Museum.

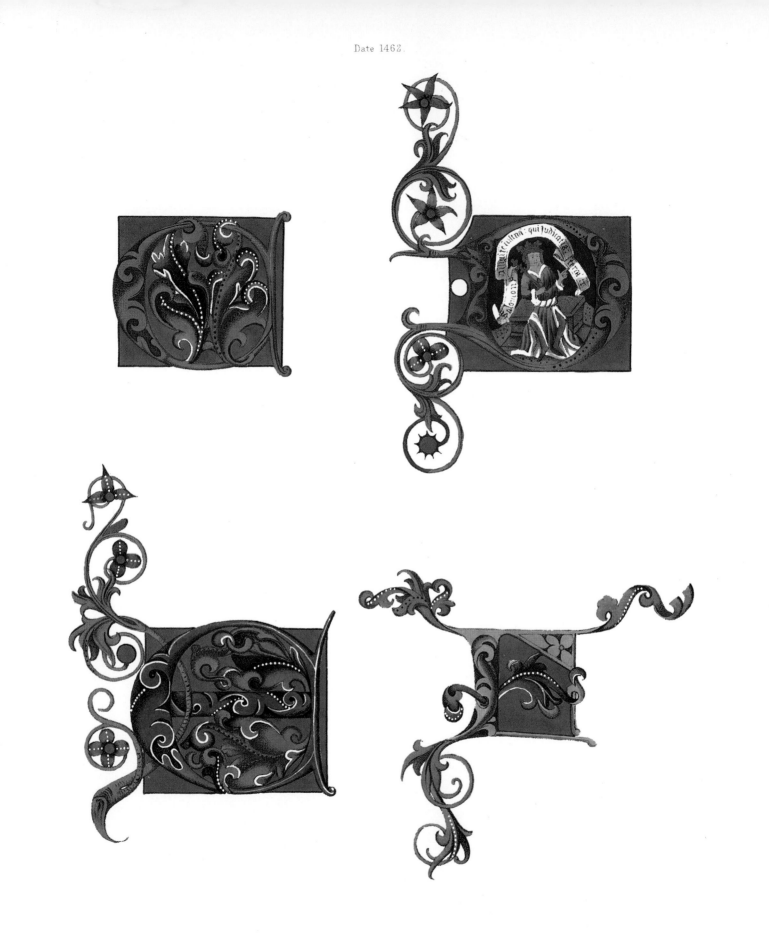

FROM FUST AND SCHOIFFOERS BIBLE.

In the British Museum.

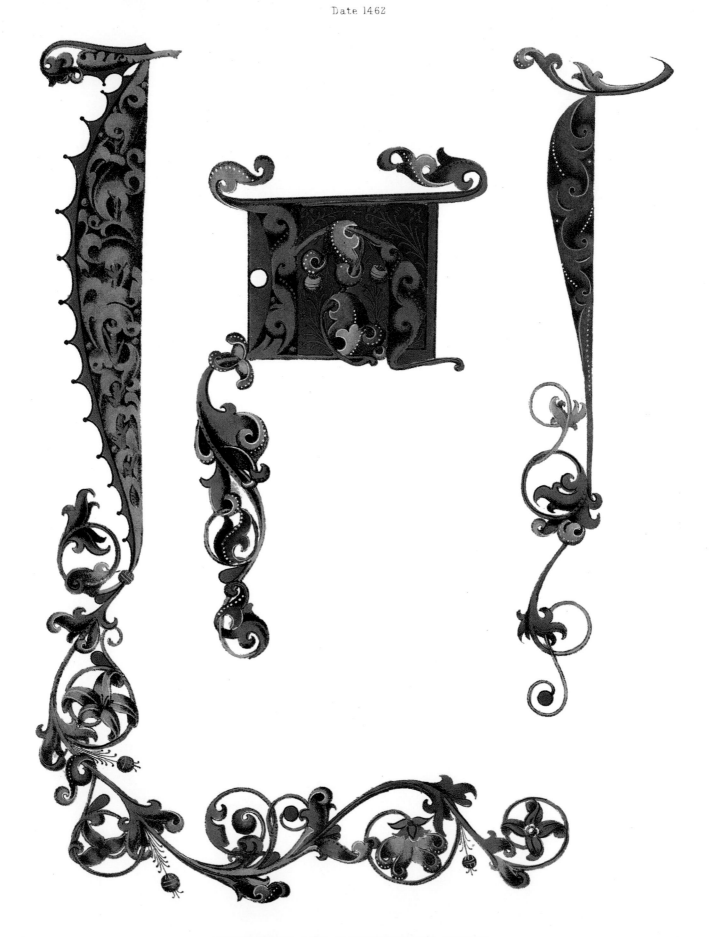

FROM FUST AND SCHOIFFOERS BIBLE.

In the British Museum.

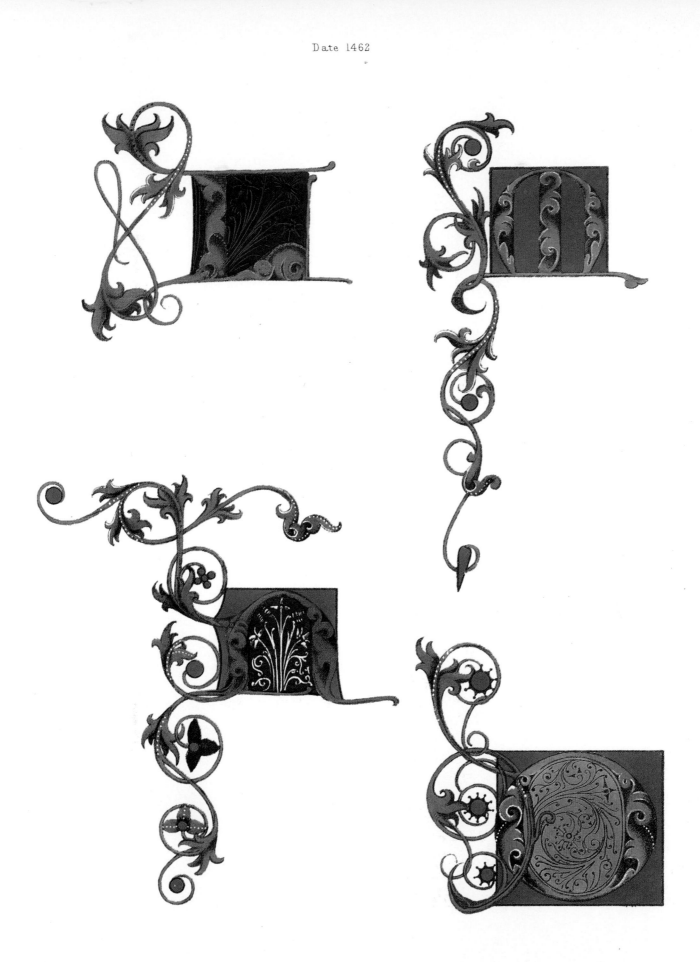

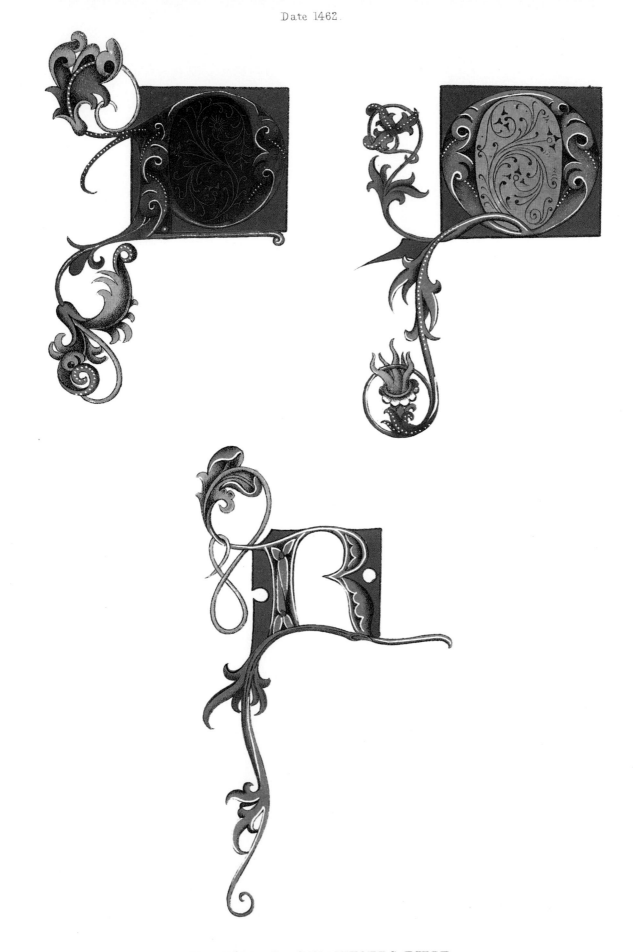

FROM FUST AND SCHOIFFOERS BIBLE.

In the British Museum.

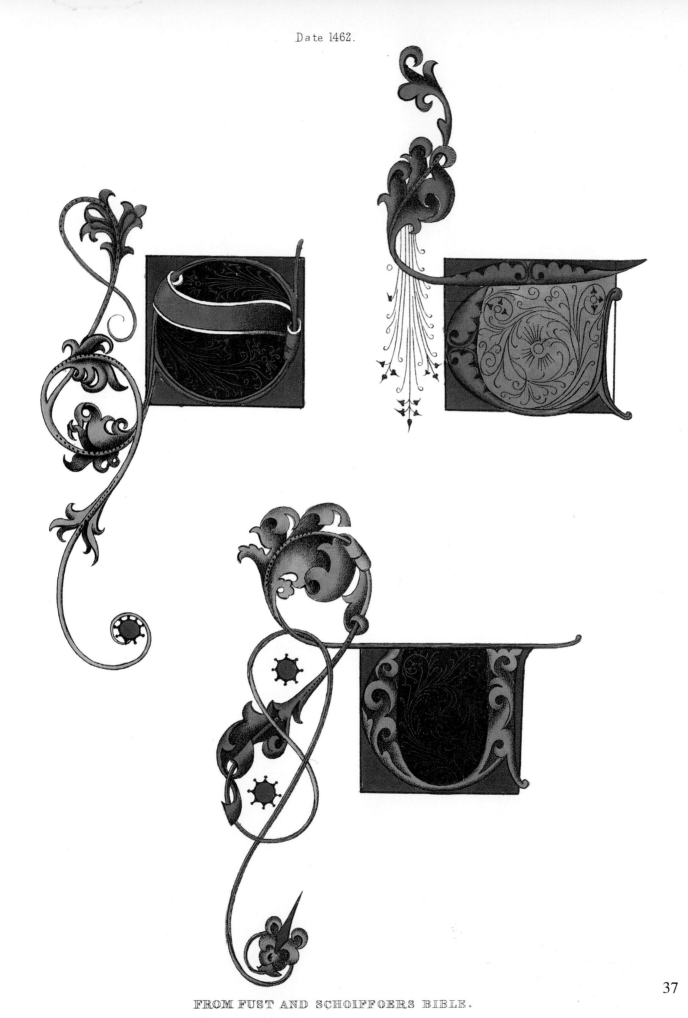

FROM FUST AND SCHOIFFOERS BIBLE.

In the British Museum.

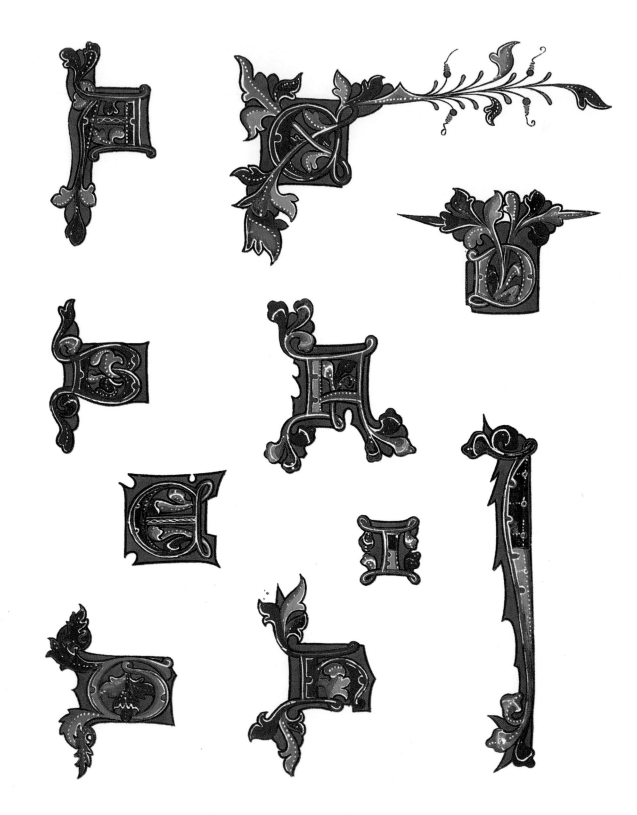

FROM LANSDOWNE MS. 451. IN THE BRITISH MUSEUM.

Date about 1470.

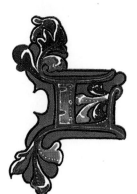
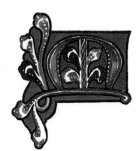
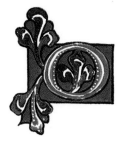

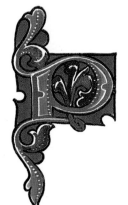
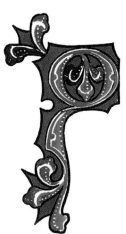
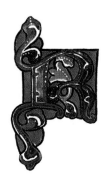

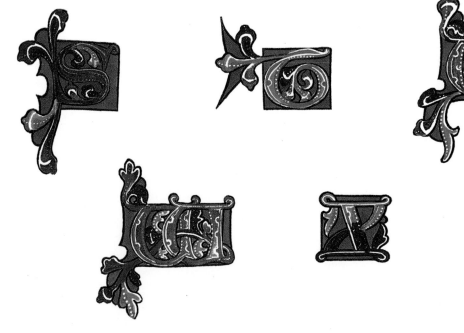

FROM LANSDOWNE MS. 451. IN THE BRITISH MUSEUM.

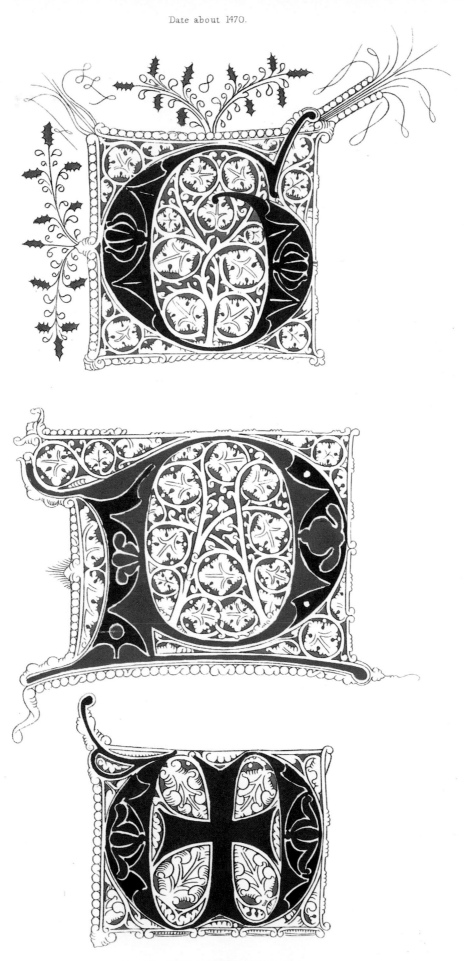

FROM A MISSAL

In the poſſeſſion of the Revᵈ W. Maskell.

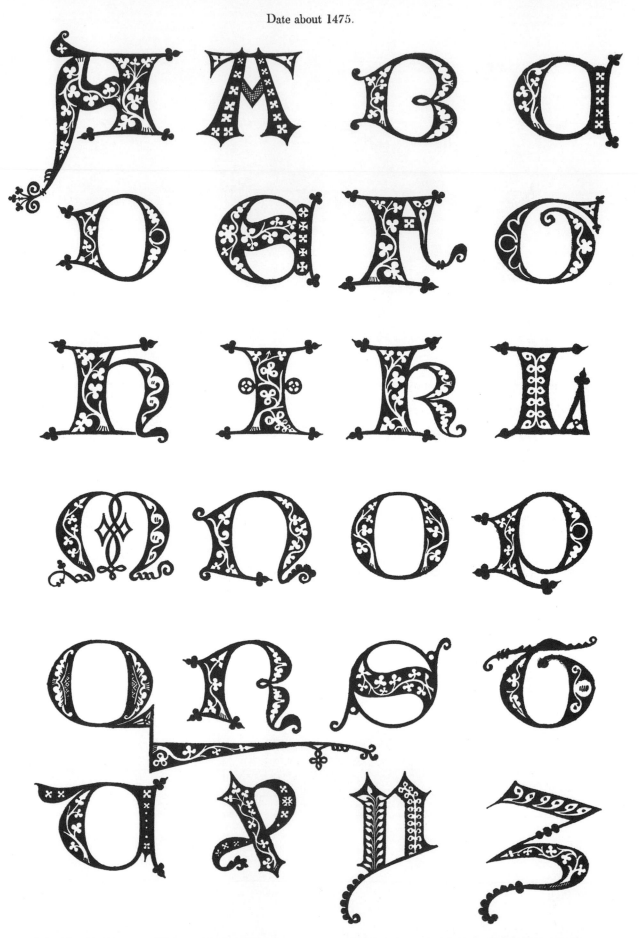

FROM SUMMA BARTHOLOMÆI PISANI ORD. PRÆDIC. DE CASIBUS CONSCIENTIÆ.

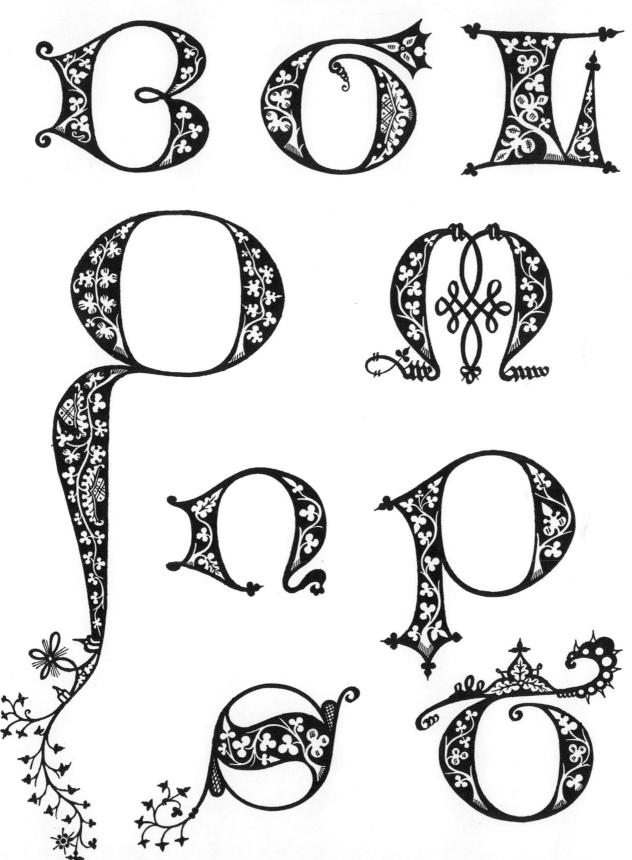

FROM SUMMA BARTHOLOMÆI PISANI ORD. PRÆDIC. DE CASIBUS CONSCIENTIÆ.

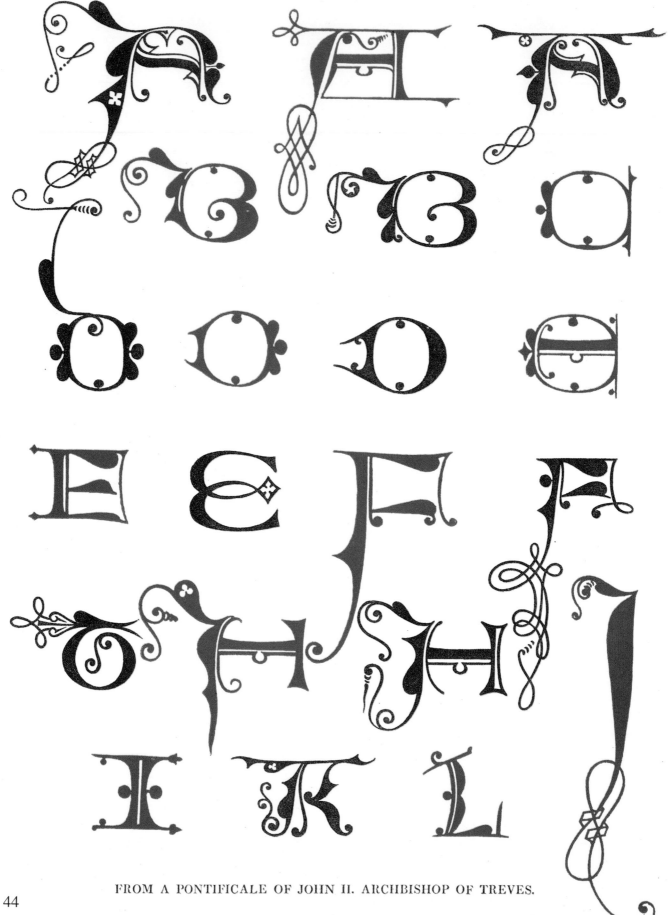

FROM A PONTIFICALE OF JOHN II. ARCHBISHOP OF TREVES.

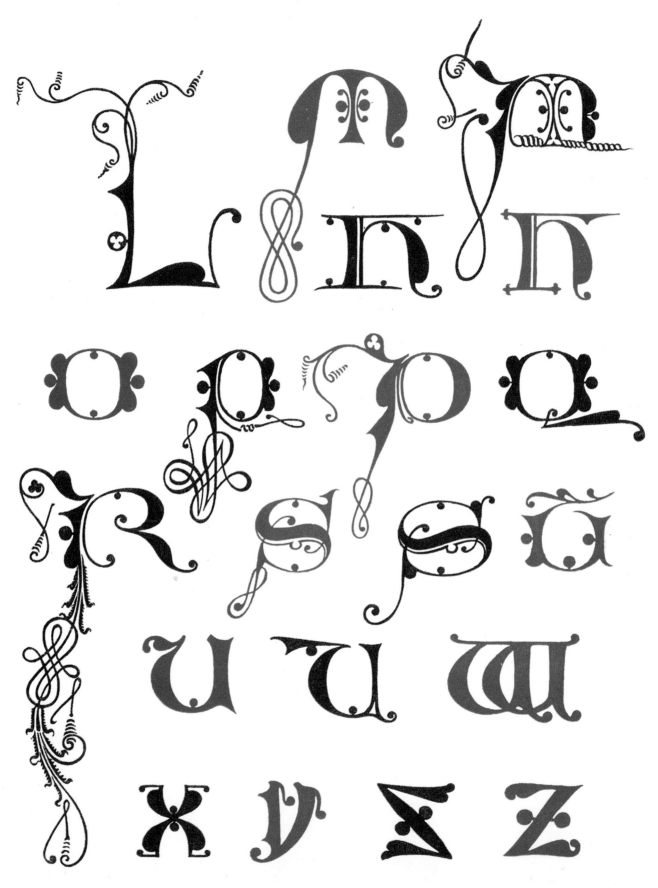

FROM A PONTIFICALE OF JOHN II. ARCHBISHOP OF TREVES.

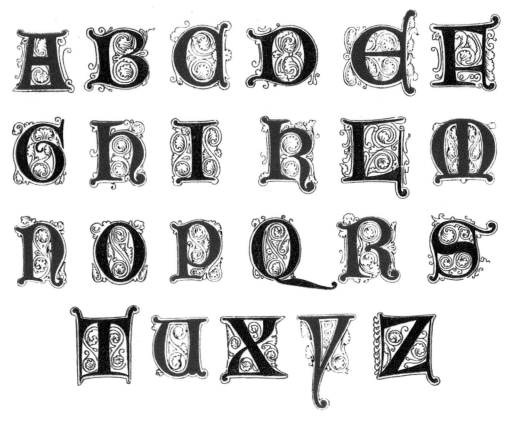

FROM A MS. AT ROUEN.

Date about 1480.

FROM A BENEDICTIONALE IN THE POSSESSION OF THE
REV. W. MASKELL.

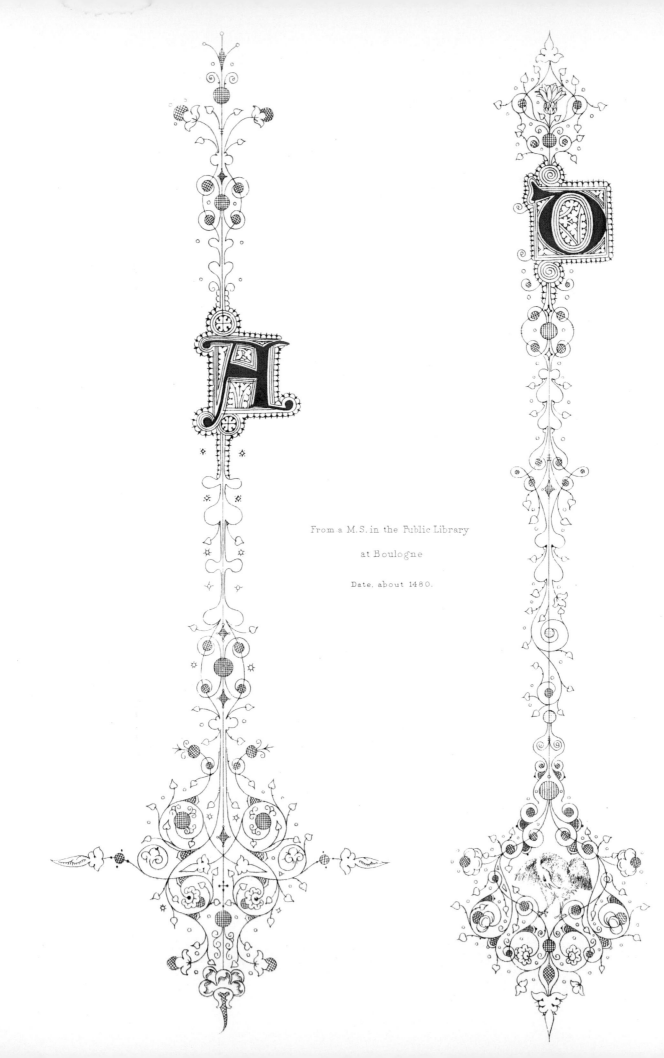

From a M.S. in the Public Library

at Boulogne

Date, about 1480.

49

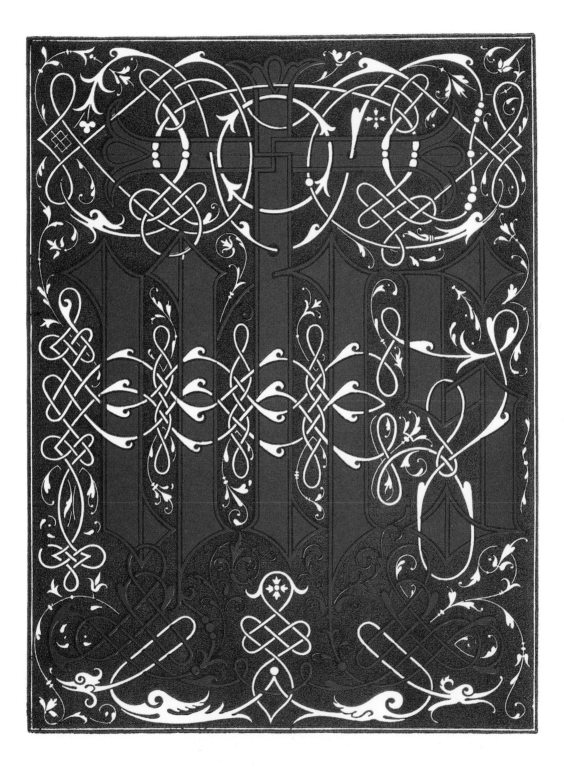

FROM AN ENGRAVING ON WOOD.

From various M.S.S. in the British Museum.

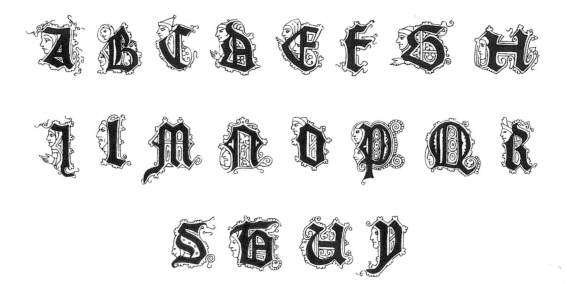

From a M.S. in the possession of Philip Hanrott Esq^re

Brit. Mus^m Vespasian A. II.
Date 13^th Cent^y

Brit. Mus^m Arundel 343
Date 14^th Cent^y

Brit. Mus^m Lansdown M.S. 451
Date about 1470.

From a M.S. 15^th Century.

In the Church of S^t Egide, Nuremberg.
1457. 1468. 1515.

From Salisbury Cathedral.

In Iron on a House
near Aix la Chapelle.

A la Cour Imperial Ostend.

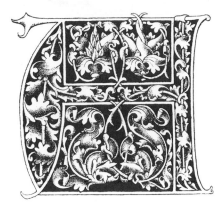
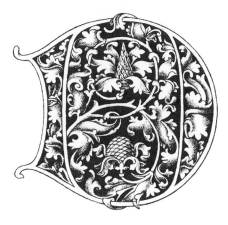

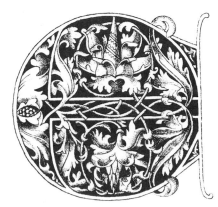
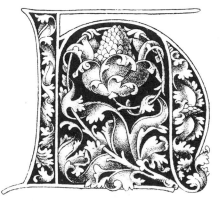

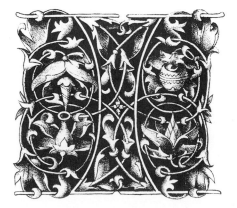
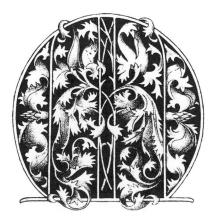

FROM A VOLUME ENTITLED PRESERVATION OF BODY, SOUL, HONOR, AND GOODS.

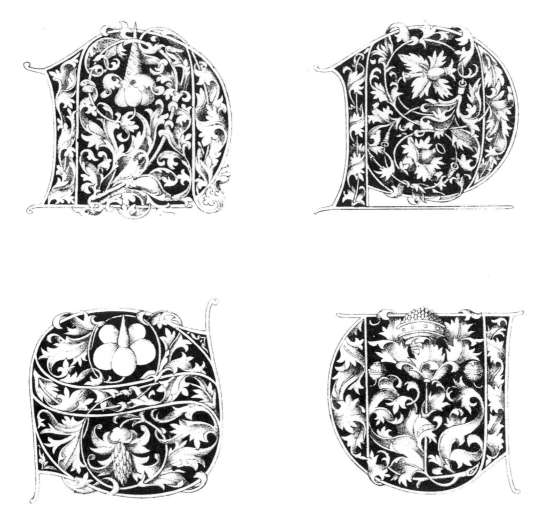

FROM A VOLUME ENTITLED PRESERVATION OF BODY, SOUL, HONOR, AND GOODS.

NURENBERGH.

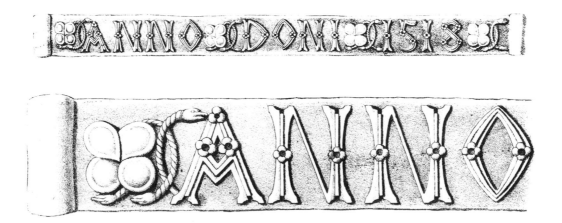

FROM A GATEWAY IN CHANCERY LANE.

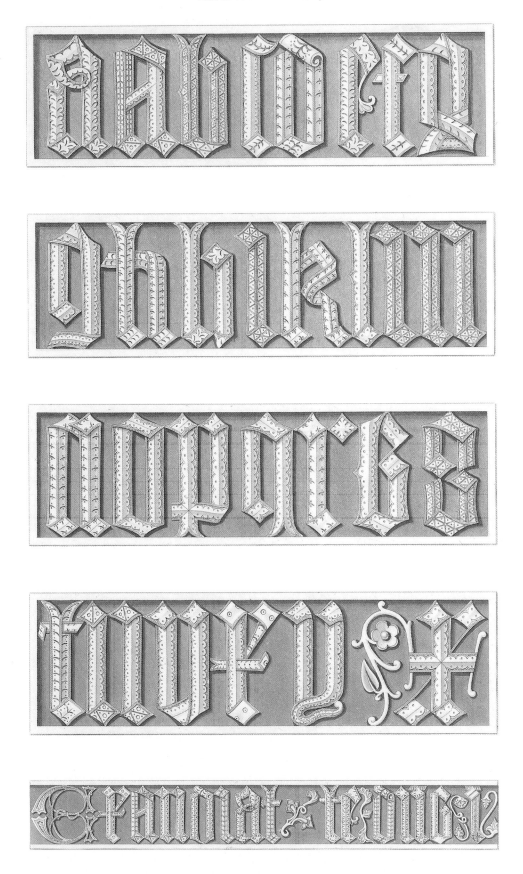

FROM THE STALLS

in St George's Chapel, Windsor.

H. Shaw.

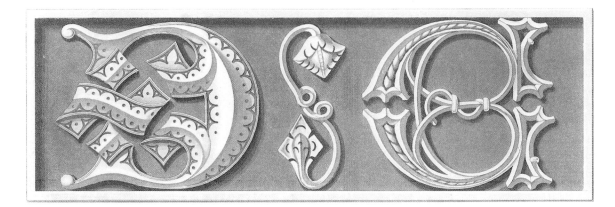

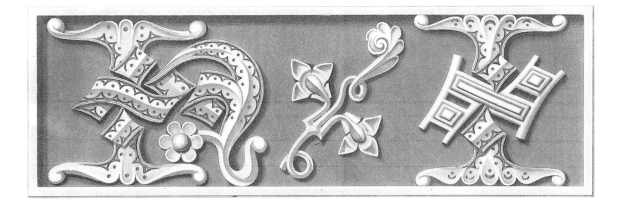

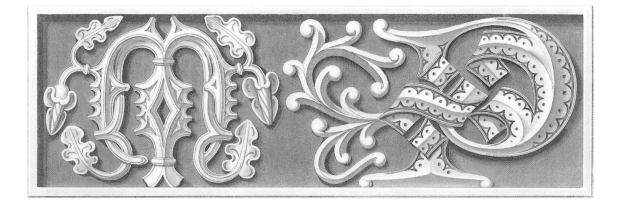

FROM THE STALLS.

in S^t George's Chapel, Windsor.

H. Shaw.

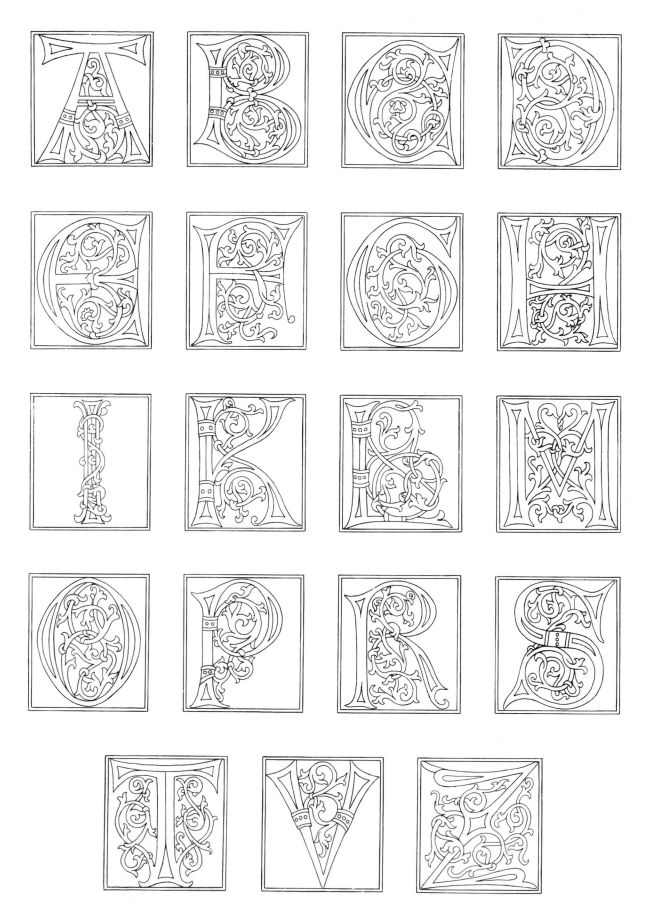

FROM THE GOLDEN BIBLE.

Printed at Augsburg.

Date, the beginning of the 16th Century.

 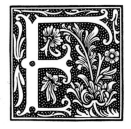

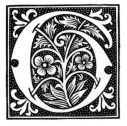 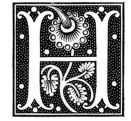 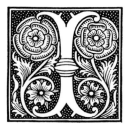

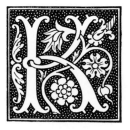 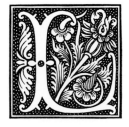 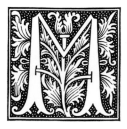

FROM A COPY OF THE ROMANT DE LA ROSE.

Date, the beginning of the 16th Century.

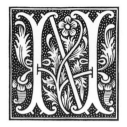 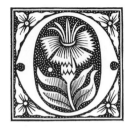 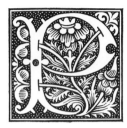

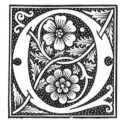

 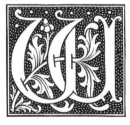

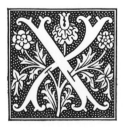 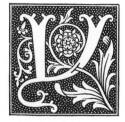 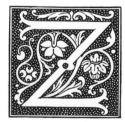

FROM A COPY OF THE ROMANT DE LA ROSE.

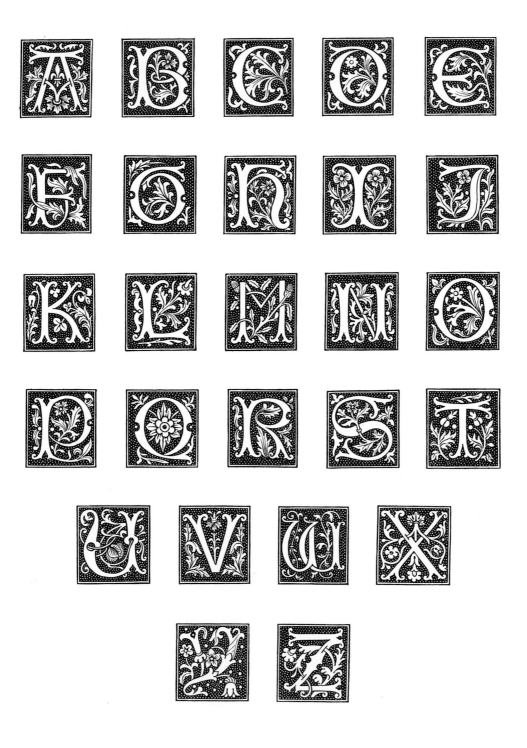

FROM WOOD CUTS.

Date, 1515.

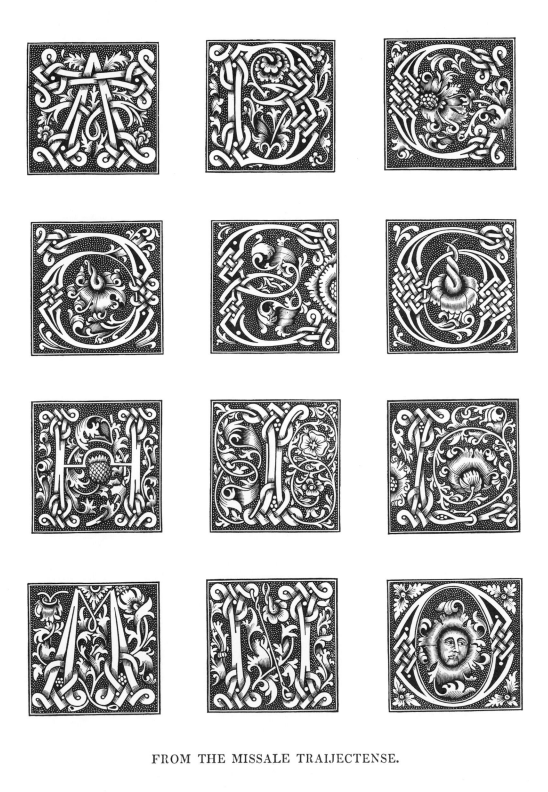

FROM THE MISSALE TRAIJECTENSE.

73

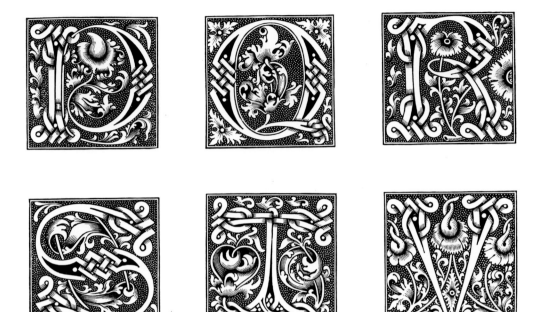

FROM THE MISSALE TRAIJECTENSE.

ALPHABETS OF END OF THE FIFTEENTH CENTURY.

Date, the beginning of the 16th Century.

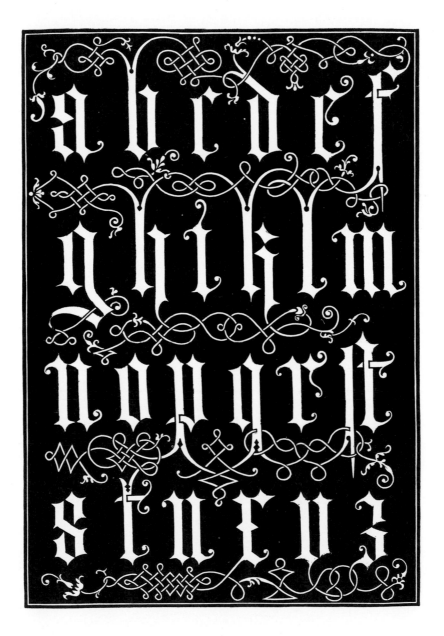

FROM AN ENGRAVING ON WOOD.

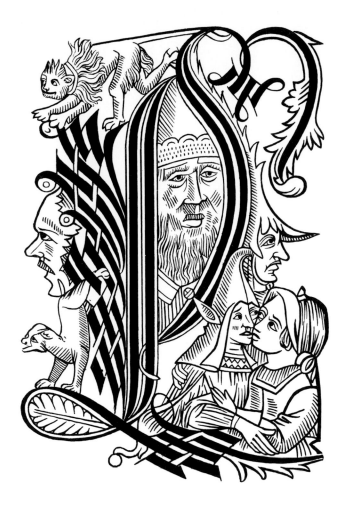

From Lancelot du Lac.

From Luis de Escobar.
Las Quatro Cientas del Almirante. 1550.

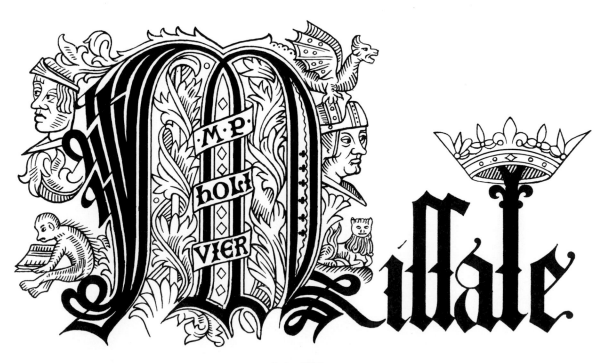

Date 1516.
MISSALE EBORACENSIS ECCLESIÆ.

Date, 1530.

FROM THE HYSTOIRE DE PERCEVAL LE GALLOYS.

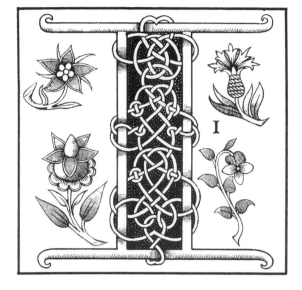

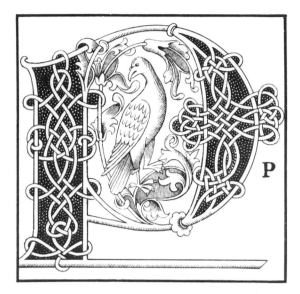

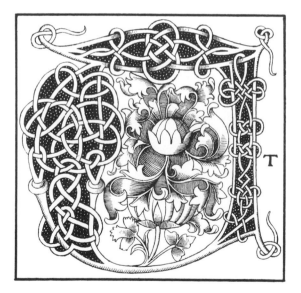

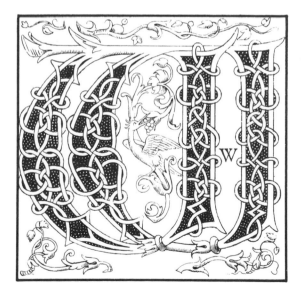

FROM CRANMER'S BIBLE.

Date, 1547.

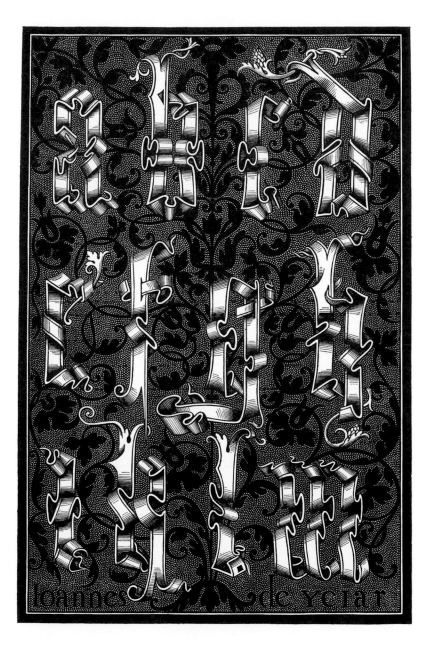

RIBAND LETTERS.

Date, 1547.

RIBAND LETTERS.

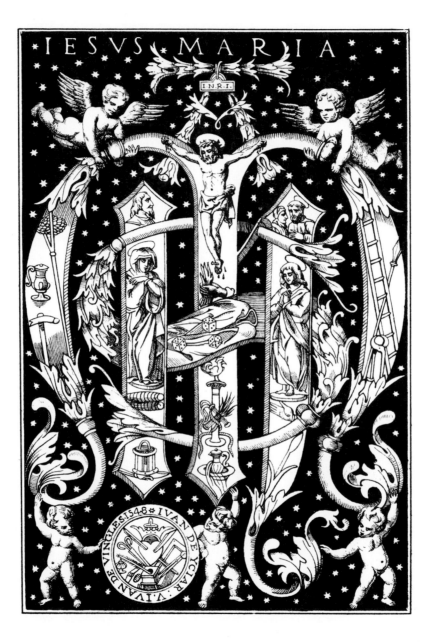

SACRED MONOGRAM.

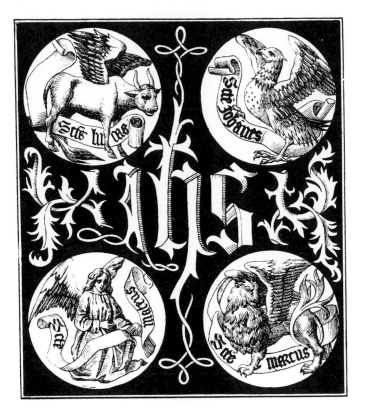

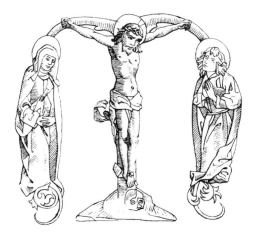

FROM A PRINTED BOOK.

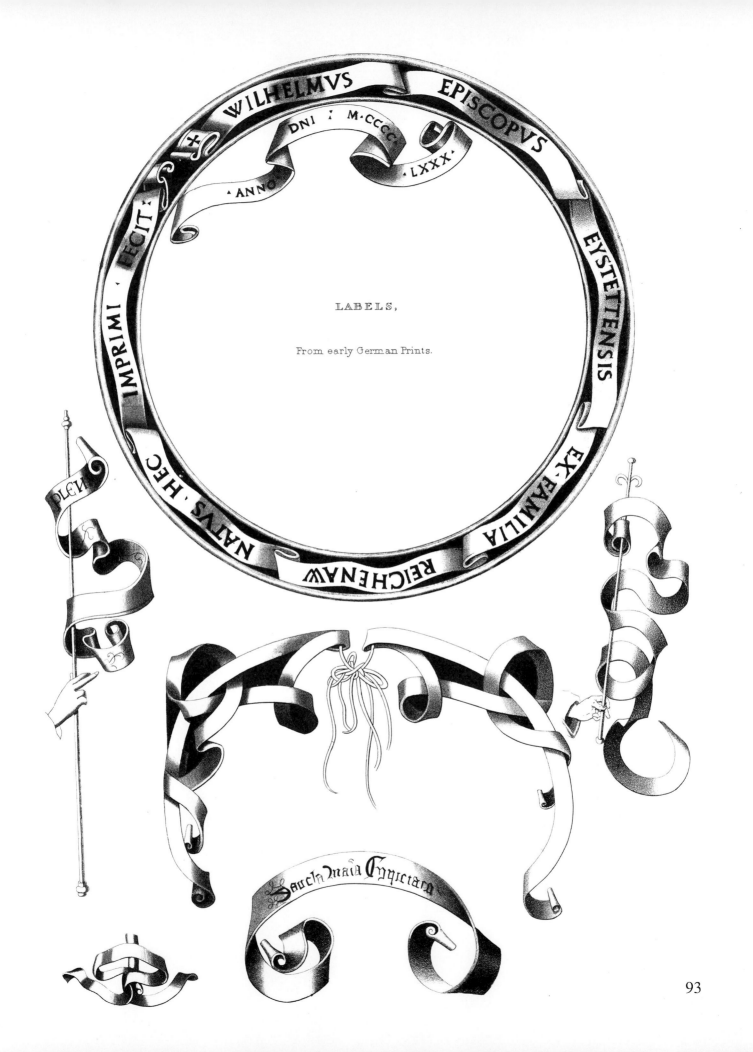

LABELS,

From early German Prints.

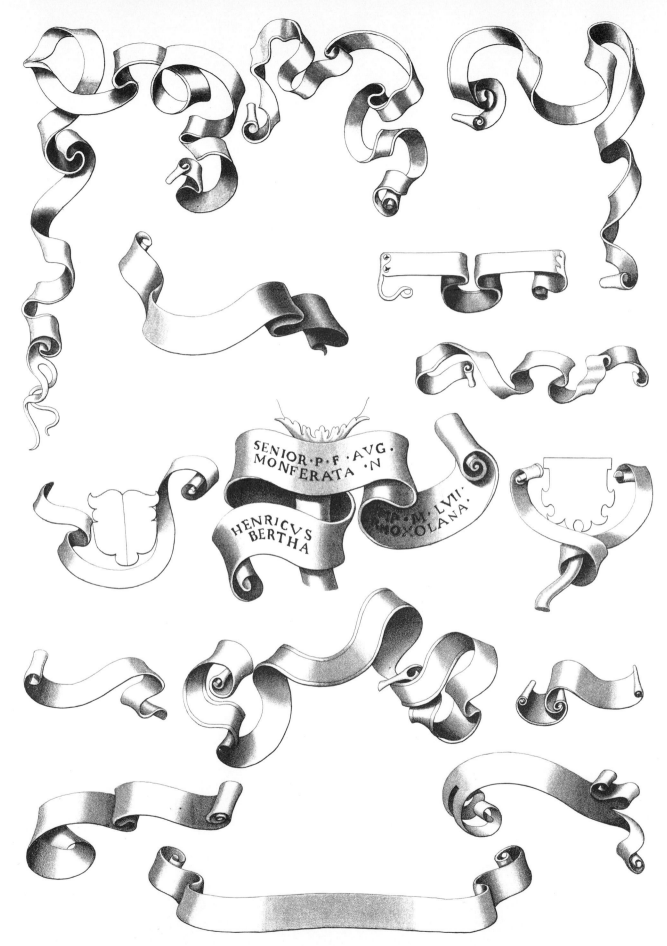

LABELS,

From early German Prints.